Walter Sickert
Sketches of Life

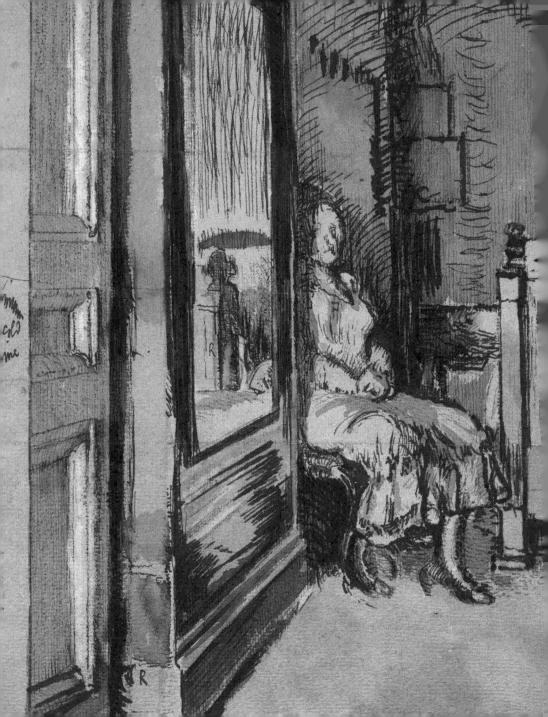

Walter Sickert
Sketches of Life

Works from the Tate Collection

Edited by Thomas Kennedy

Sickert

Londra benedetta!

Introduction

*Any fool can paint, but drawing is the thing and drawing is the
test. If you are a good draughtsman you are ipso facto a good
painter*[1] – Walter Sickert

The drawings included in this publication reveal the working prac-
tice of Walter Sickert, one of the most distinctive and impor-
tant British artists of the late nineteenth and early twentiethth
centuries. Sickert was a prolific draughtsman throughout his
career and used his drawings as preparatory works for his paintings. He
frequently visited locations again and again, investing long periods of time
to detail certain elements or drawing (and sometimes even redrawing)
entire views. By doing so, Sickert was able to develop ideas and concepts
before an image might be transferred to canvas. As mentor and teacher
to a younger generation of artists, he also attempted to teach the use of
preparatory drawings to his protégés, thereby steering the course of arts
practice in Britain. The selection of drawings stored in Tate's collection
and archive capture the intricacies of architecture, the infectious thrill of
performance, and even the nuances of a subject's character. They not only
serve as a record of Sickert's creative process but express his engagement
with the world around him, both in Britain and abroad.

As a young man, Sickert had been an apprentice to the American
artist James Abbott McNeill Whistler, who taught him the importance
of direct observation when creating works on location.[2] Years later, in
1883, he carried his master's painting *Arrangement in Grey and Black No. 1*
(commonly known as *Whistler's Mother*) to an exhibition in Paris where he
met the French impressionist Edgar Degas for the first time.[3] Sickert was
profoundly influenced by the artist, and during a shared sketching trip in
the countryside, Degas shared an opinion on art that Sickert never forgot:
'I always tried to urge my colleagues to seek for new combinations along
the path of draughtsmanship, which I consider a more fruitful field than
that of colour'.[4] Following the French artist's example, Sickert committed
himself to the process of drawing initial studies on paper before compos-
ing his paintings. Years later, in 1914, Sickert detailed his own thoughts on

Londra benedetta published in 'The New Age', p.300, 27 July 1911,
lithographic reproduction on paper, 33 × 22, Tate Archive

the differentiation between a painter and a draughtsman-painter which Degas had encouraged:

> *If he be only a painter, and not a draughtsman, he will be able to give you something, something beautiful, something with a certain charm of execution and colour, something to which will even cling a faint scent of the magic moment, but it will be a faint sensation only, to which he will give a degree of permanence. The work will be wanting in bite, in bulk, in depth, in resonance, and in uniqueness. But if the painter is doubled with the draughtsman, we get the supreme work.*[5]

Some of Sickert's earliest drawings were made in small sketchbooks, unobtrusively documenting the features of patrons in cafés, theatres and music halls.[6] But his drawings soon extended to other subjects – from studies of the street and the architecture of buildings and churches to formal portraits, female nudes and scenes depicting interactions between two participants. Sickert believed that 'wilful distortions' from nature should be avoided and that drawings should be realistic and accurate. Instructive notes on his sketches, such as labelling buildings or indicating particular colours, highlight his commitment to their accuracy (see pages 20–21). As a result, his sketches possess the keen sense of realism and raw human emotion often found in reportage photography.[7]

However, to create paintings of complex scenes, Sickert often used individual studies to 'build up' compositions. These elements were composed separately, then put together to create an intricate collage of ideas. In drawings for his painting *The Café Suisse (Café des Arcades, Dieppe, France)* c.1914 (see pages 22–3) he drew individual patrons, then their place against the café architecture before refining his viewpoint. Back at his studio, he also often made further drawings from memory, in varying degrees of detail. These individual elements could then be redrawn into a work which was a cohesive rendering of what he had seen. The final stage of the process was to transfer the image to canvas by a 'transfer grid' technique (see page 25). In a 1930 article in the *Manchester Guardian*, one of his students described the process Sickert taught them:

He showed us how to draw lines across our sketch, in the form of a draughtboard, with all the squares of uniform size, the size depending on the actual sketch and the amount of detail. Then taking a sheet of thin paper, drawing a similar set of squares, but multiplying the size by two, three or as many times as was necessary to cover a canvas of the ultimate size of the picture. We then had to draw in each square a copy of the portion of the drawing which we found in the corresponding small square in our original sketch. When this was finished we had a drawing of the necessary size, but all covered with squares.[8]

Sickert was an avid proponent of the process, commenting to his friend and fellow artist Ethel Sands, that the grid made it possible to 'readjust every time everything to renewed information'.[9] Though elements and views were created from life, his 'built up' drawings and paintings are a result of weaving together a narrative from segments of reality. In doing so, Sickert was able to create and refine new stories such as a writer of fiction may do: as David Sylvester wrote in *Artforum* in May 1967, Sickert's drawings are 'highly psychological, with a novelist's eye for specific human tensions'.[10] His poignant compositions reverberate with human stories, and show how he perceived and captured the world. Students of Sickert, as well as members of the Camden Town Group, including Charles Ginner and Spencer Gore, adopted the method to convey narratives in their own works.

The drawings in Tate's collection and archive predominantly highlight his time living in Dieppe – visits to music halls and views of cafés, religious sites and monuments in the small seaside town. Many of the drawings from Dieppe belonging to Tate were gifted by Mrs Andrina Tritton in 1981. She had inherited the works from the estate of her mother, Mrs Andrina Schweder, the sister of Walter Sickert's second wife Christine Angus, whom he married in 1911. The drawings reveal Sickert's unwavering skill as a draughtsman, showing representations of his everyday life and his key role in creating an artistic dialogue between France and Britain.

Dieppe

Dieppe was a sanctuary for Walter Sickert. He was a regular visitor to the French seaside town and spent time there with influential artists including impressionist Edgar Degas. The studies and drawings in this section were composed following his marriage to his second wife Christine Angus in 1911. The newlyweds spent their honeymoon in Dieppe and bought a villa in the nearby town of Envermeu, ten miles inland from Dieppe. Though Sickert sketched features of the countryside surrounding his town, he also frequently visited Dieppe to capture urban views, drawing the architecture of buildings including the Church of St Jacques, as well as patrons at the popular Café des Arcades.

Drawing of 'Le Clos Normand', Martin Eglise, near Dieppe, date unknown, pencil and ink on paper, 27.1 × 19.5, Tate Archive

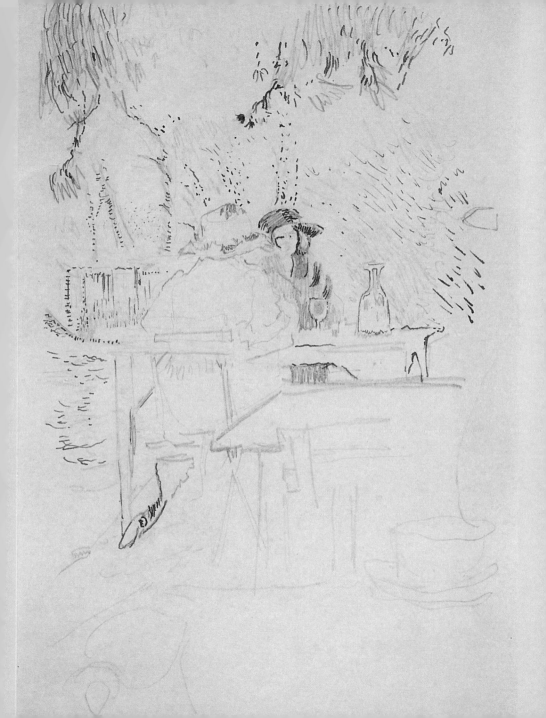

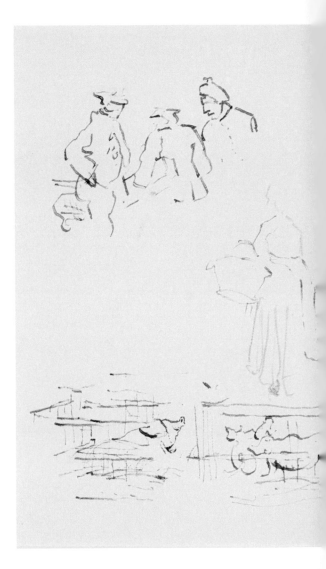

*Drawings of groups of people and pigs
at market, [near Envermeu]*, c.1913,
ink and pencil on paper, 27 × 38,
Tate Archive

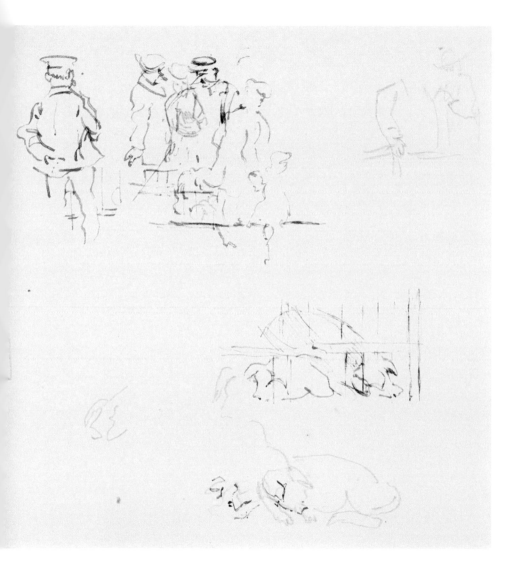

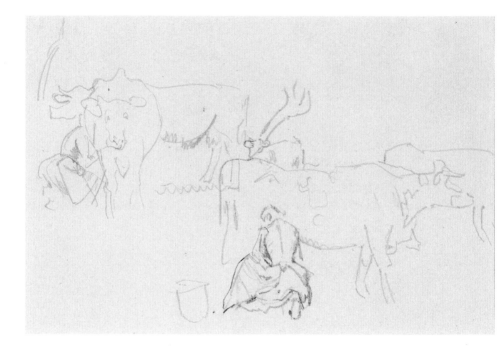

Drawing of cows being milked, Envermeu/Arques area, date unknown,
pencil on paper, 19.2 × 27.8, Tate Archive

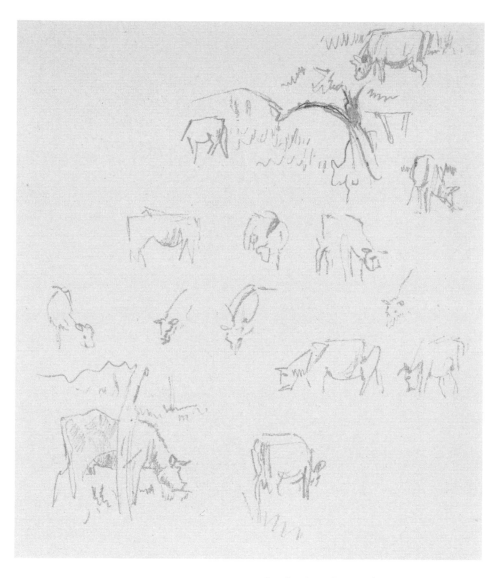

Drawing of cows, Envermeu/Arques area, date unknown,
pencil on paper, 27.8 × 19.2, Tate Archive

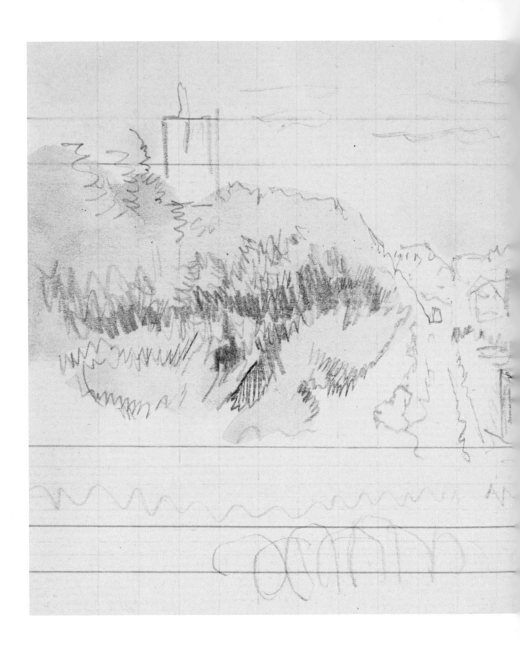

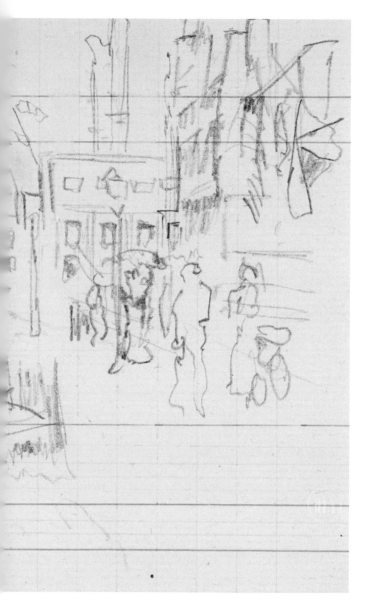

Drawing of Dieppe and environs, c.1914, pencil and watercolour on paper, 10.3, × 16.5, Tate Archive

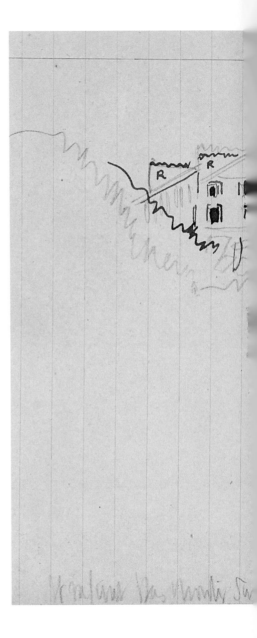

Drawing of hill and houses, Dieppe,
date unknown, pencil and ink on paper,
17 × 21.7, Tate Archive

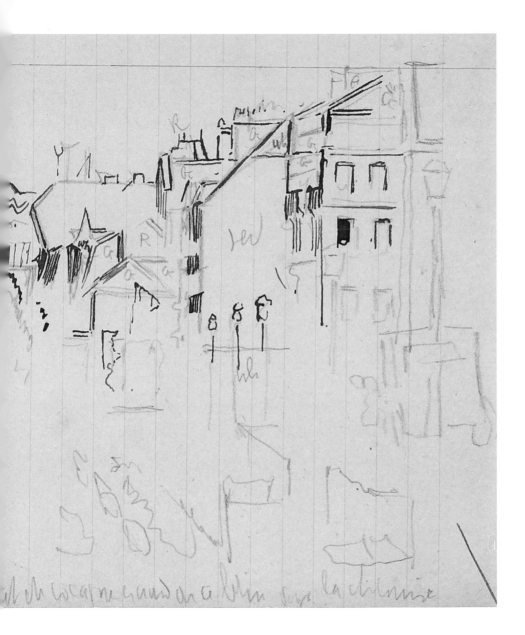

17

Drawing of street in Dieppe with flags and car, date unknown,
pencil and ink on paper, 21.7 × 17, Tate Archive

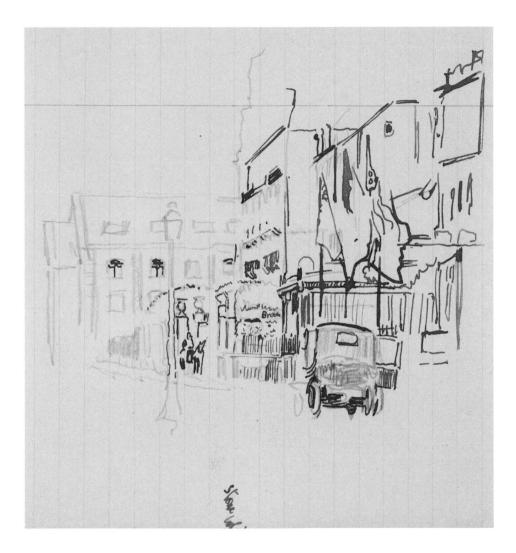

Drawing of house and square in Dieppe or environs,
date unknown, pencil and ink on paper, 17 × 21.7,
Tate Archive

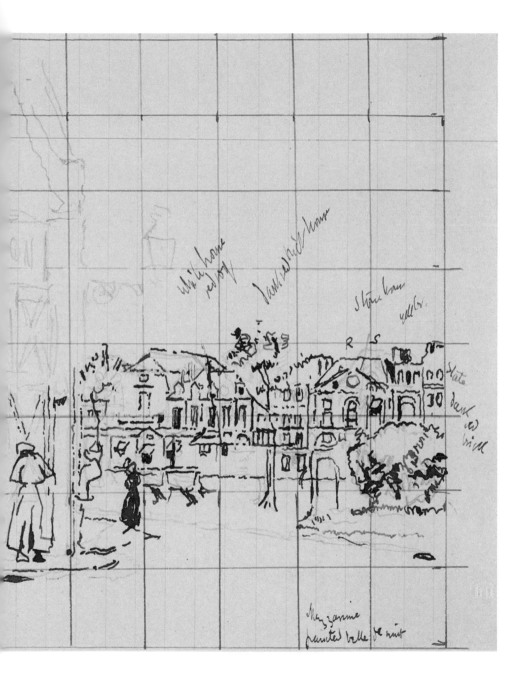

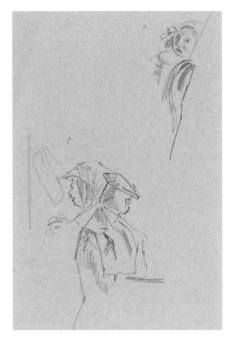

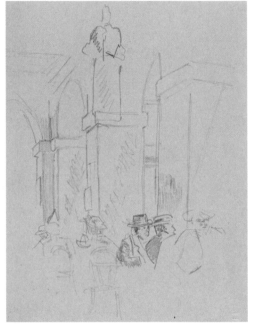

Drawing of Café des Arcades with figures, Dieppe,
c.1914, pencil on paper, 27 × 18.5, Tate Archive

Drawing of Café des Arcades with seated figures, Dieppe, c.1914,
pencil on paper, 22 × 17, Tate Archive

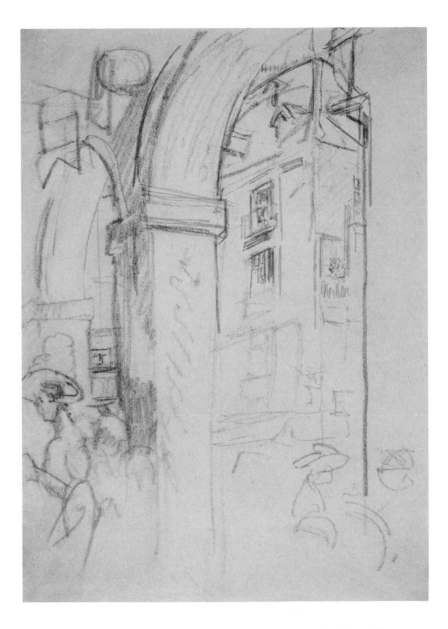

Drawing of Café des Arcades with female figures, Dieppe, c.1914,
pencil and charcoal on paper, 29 × 20.6, Tate Archive

Drawing of Café Suisse/Café des Arcades, Dieppe, c.1914,
pencil and watercolour on paper, 39.4 × 25.9, Tate Archive

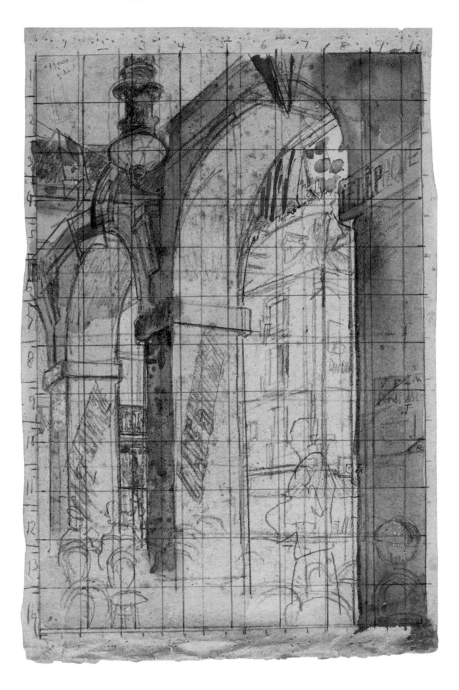

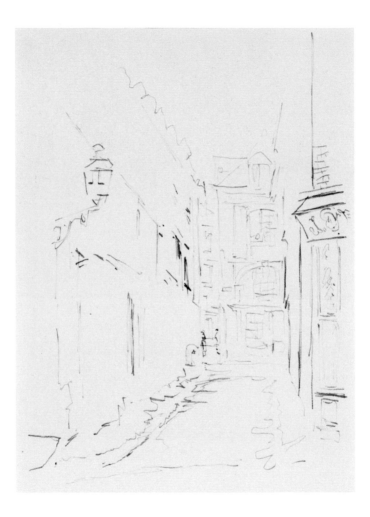

Drawing of a street with wall lantern, Dieppe, date unknown,
ink on paper, 27.7 × 18.9, Tate Archive

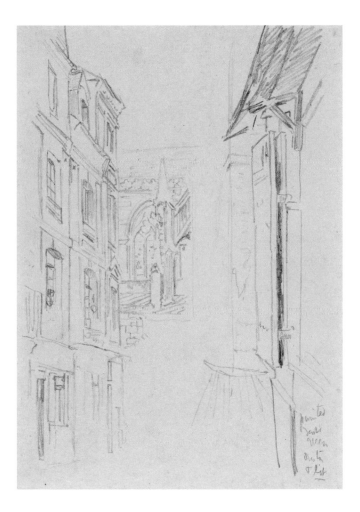

Drawing of Rue Pecquet, looking towards the church of Saint Jacques, Dieppe,
1907–14, pencil on paper, 27 × 18.5, Tate Archive

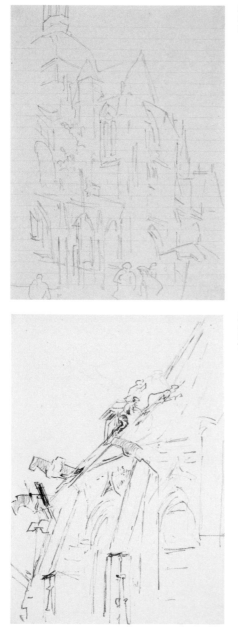

Drawing of the south façade, Saint Jacques, Dieppe, date unknown, pencil on paper, 21.7 × 17, Tate Archive

Drawing of workmen on the roof of the church of St Jacques, Dieppe, date unknown, ink and pencil on paper, 27.8 × 19, Tate Archive

Dieppe, Study No. 2; Facade of St Jacques, c.1899, carbon paper tracing and watercolour on paper, 32.3 × 23.4, Tate

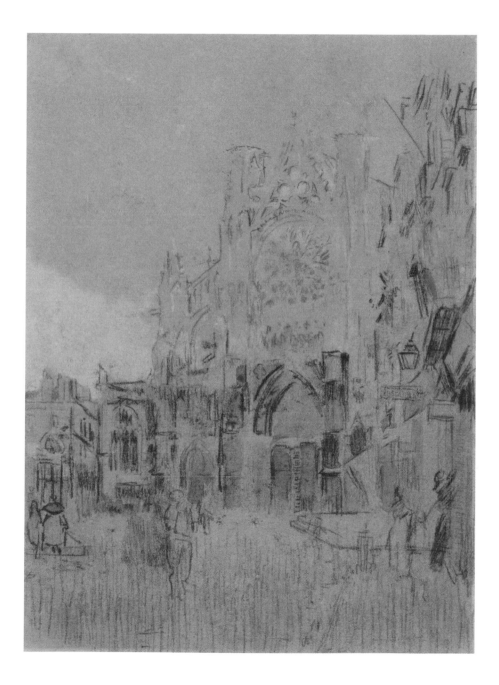

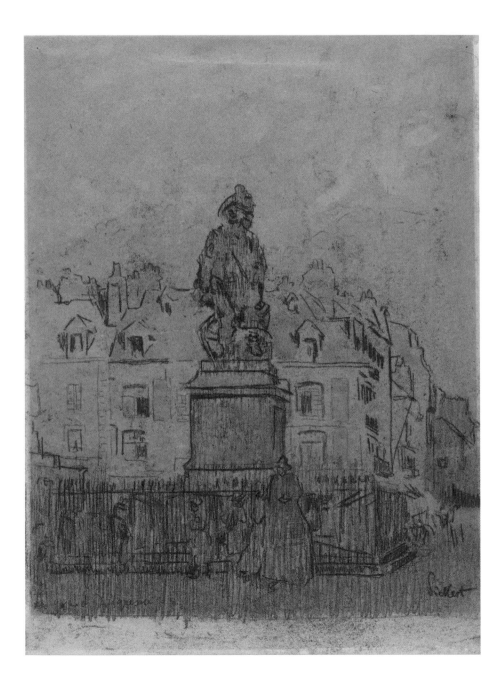

Sketch for 'The Statue of Duquesne, Dieppe', c.1900,
carbon paper tracing and watercolour on paper,
32.4 × 23.5, Tate

The Music Hall

The music hall is one of Walter Sickert's most recognisable subjects, and his series of works depicting it instigated his rise to prominence. A former actor, he had appeared in many performances, from *Henry V* and *The Lady of Lyons* to *Othello* and *A Midsummer Night's Dream*. After choosing to become an artist, he never relinquished his love for the stage. Sickert almost always sketched during visits to music halls, capturing a performer on stage or turning his gaze to the captivated audience. As well as the music hall he also sketched other performative venues including travelling circuses, where he witnessed high-flying acrobats, clowns and even a boxing kangaroo.

Drawing of a theatre/music hall audience, [Vernet's café-concert, Dieppe], c.1919–20, ink on paper, 30.3 × 23, Tate Archive

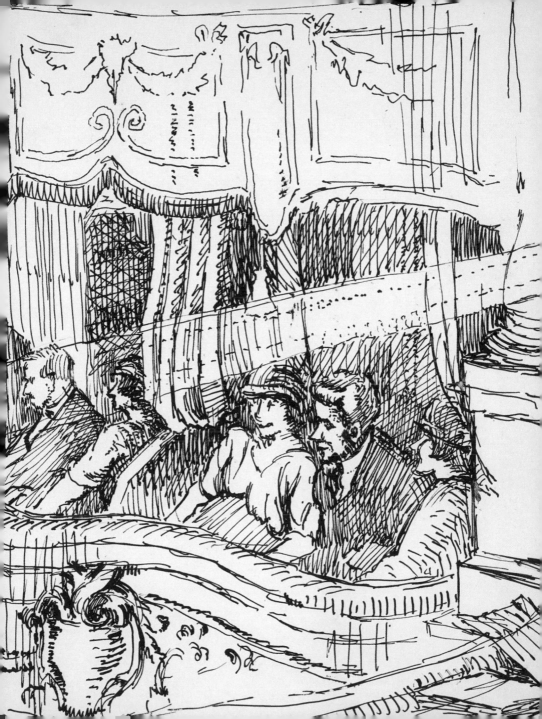

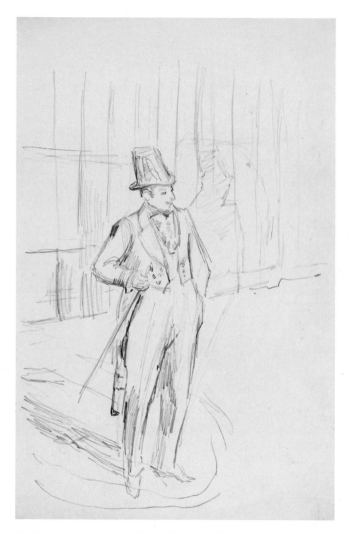

Drawing of a man in top hat and coat tails on stage, [Vernet's café-concert, Dieppe],
c.1919–20, pencil on paper, 35 × 22.9, Tate

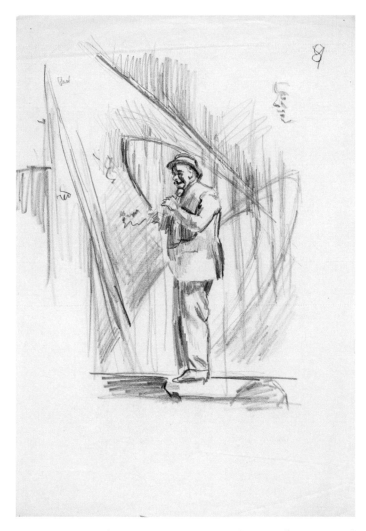

Drawing of a man in hat and jacket on stage, [Vernet's café-concert, Dieppe],
c.1919–20, pencil on paper, 38 × 25.5, Tate

Drawing of a ballerina pirouetting, date unknown,
ink on paper, 37 × 23.5, Tate Archive

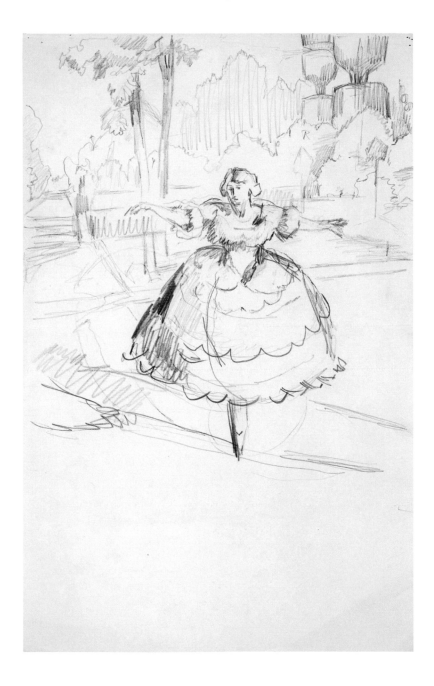

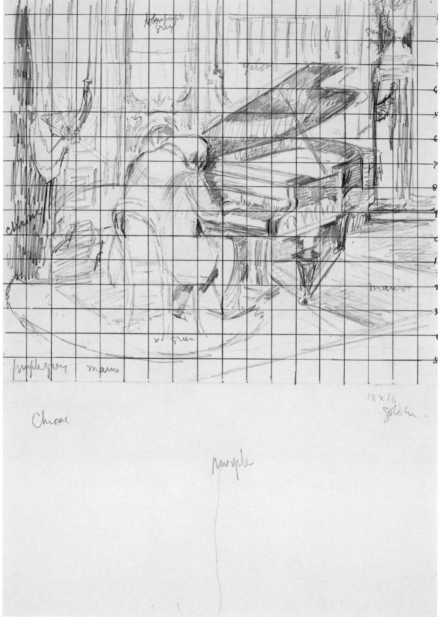

Drawing of a music hall concert, [Shoreditch], c.1920,
pencil and ink on paper, 35.5 × 23, Tate Archive

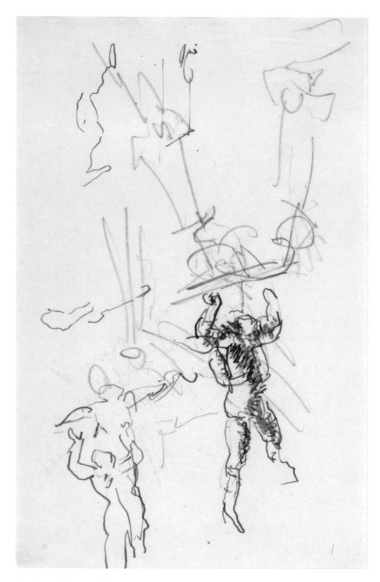

Drawing of circus acrobats, c.1919, ink and pencil on paper, 27.2 × 21, Tate Archive

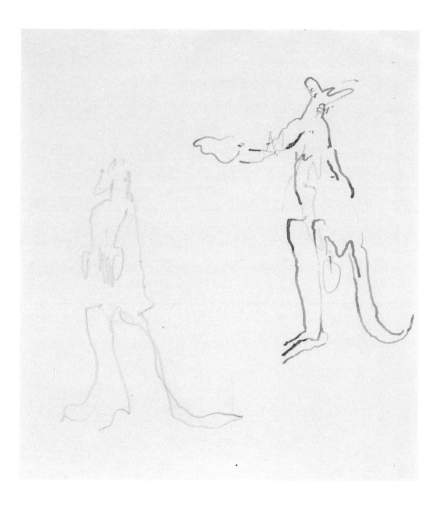

Drawing of circus kangaroos, c.1919, ink and pencil on paper, 27.2 × 21, Tate Archive

Modern Conversation Pieces

This section includes studies for three paintings in Tate's collection – *Ennui* c.1914, *L'Armoire à Glace* 1924, and *The Little Tea Party: Nina Hamnett and Roald Kristian* 1915–16. They all relate to Sickert's interest in capturing interactions between two participants. The study for *Ennui* (meaning 'boredom' or 'listlessness' in French) exemplifies this theme, suggesting a tense relationship between the two figures, shown by their lack of communication in a suffocating environment. Unlike other works from this period, the study for *The Little Tea Party* depicts the strained relationship between a real couple, artist Nina Hamnett and her then-husband Roald Kristian.

Study for 'Ennui', 1913–14, ink on paper, 41.9 × 34, Tate

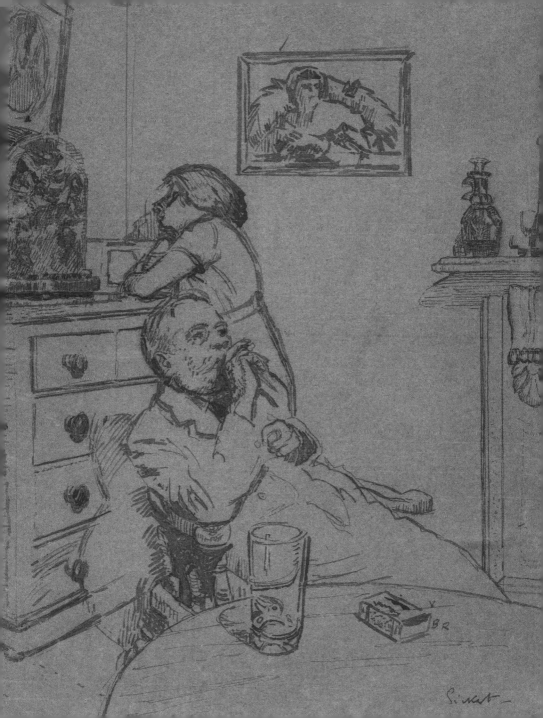

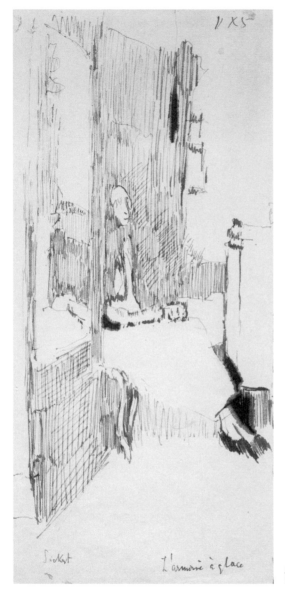

Study for 'L'Armoire à Glace', c.1922,
ink on paper, 28.1 × 13.2, Tate

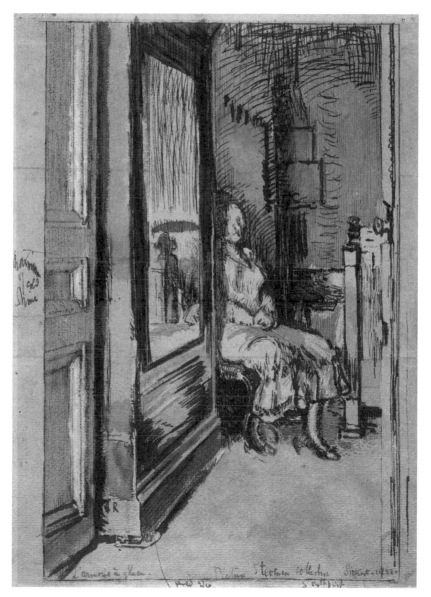

Study for 'L'Armoire à Glace', c.1922, graphite, ink, watercolour and gouache on paper, 26 × 18.7, Tate

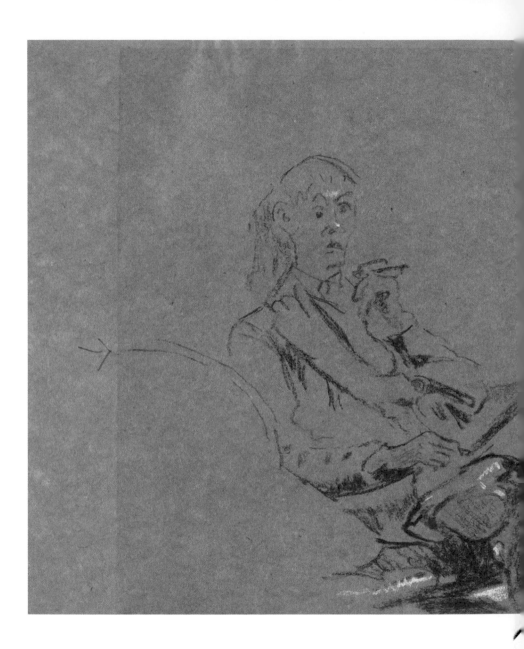

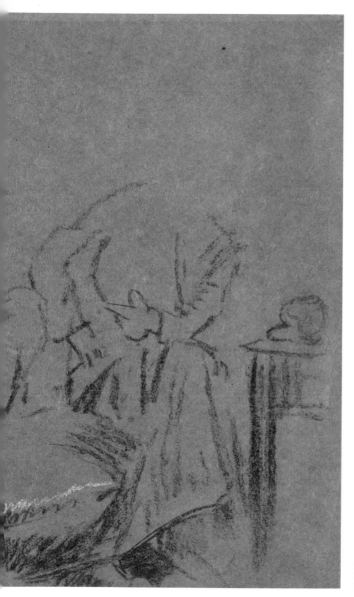

Study for 'The Little Tea Party',
c.1915–16, chalk on paper,
22.8 × 35.7, Tate

ENDNOTES

1 Quoted in Pallant House Gallery – Magazine, no.32, 2017, p.27.
2 Anna Gruetzner Robins, 'A Line "pregnant with meaning"', in *Walter Sickert: Drawing is the Thing'*, exh. cat., Whitworth Art Gallery, Manchester 2004, p.3.
3 James Abbott McNeill Whistler, letter to Oscar Wilde, May 1883.
4 Walter Sickert, 'Degas', *The Burlington Magazine for Connoisseurs*, vol. 31, no. 176, Nov. 1917, pp.184–5.
5 Walter Richard Sickert, 'A Stone Ginger', *The New Age*, 19 March 1914, pp.631–2,; reprinted in Helena Bonett, Ysanne Holt and Jennifer Mundy (eds.), *The Camden Town Group in Context*, 2012, www.tate.org.uk/art/research-publications/camden-town-group/walter-richard-sickert-a-stone-ginger-r1104295 (accessed 13 Jan. 2022).

6 Alistair Smith, 'Walter Sickert's Drawing Practice and the Camden Town Ethos', in Bonett, Holt and Mundy (eds.) 2012, www.tate.org.uk/art/research-publications/camden-town-group/alistair-smith-walter-sickerts-drawing-practice-and-the-camden-town-ethos-r1104369 (accessed 13 Jan. 2022).
7 Gabriel White, 'Sickert Drawings', *Image*, no.7, 1952.
8 *Manchester Guardian*, 31 Oct. 1930; quoted in *Walter Sickert: Drawing is the Thing'*, exh. cat., Whitworth Art Gallery, Manchester 2004, p.23.
9 Walter Sickert, letter to Ethel Sands, undated [?1913], Tate Archive TGA 9125/5, no.101.
10 David Sylvester, 'Walter Sickert', *Artforum*, vol.5, no.9, May 1967 , p.43.

First published 2022 by order of the Tate Trustees by Tate Publishing, a division of Tate Enterprises Ltd, Millbank, London SW1P 4RG www.tate.org.uk/publishing

A catalogue record for this book is available from the British Library
ISBN 978 1 84976 822 1

Distributed in the United States and Canada by ABRAMS, New York

Library of Congress Control Number applied for

Senior Editor: Alice Chasey
Production: Juliette Dupire
Picture Researcher: Roz Hill
Designed by Maggi Smith
Colour reproduction by DL Imaging, London
Printed and bound in Italy by Graphicom

FRONT COVER: Foiling design based on Walter Sickert, *Londra benedetta* published in 'The New Age', p.300, 27 July 1911 (see p.4)
FRONTISPIECE: Walter Sickert, *Study for 'L'Armoire à Glace'*, c.1922 (detail of p.45)

Measurements of artworks are given in centimetres, height before width